Flower and Fruit Paintings by **Jan van Huysum**

Miraculous
Bouquets

ANNE T. WOOLLETT

The J. Paul Getty Museum · Los Angeles

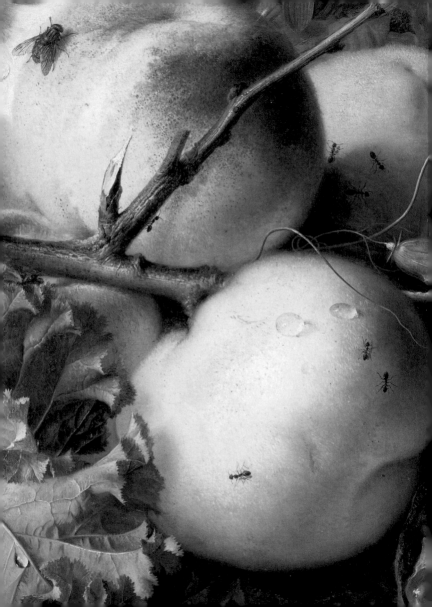

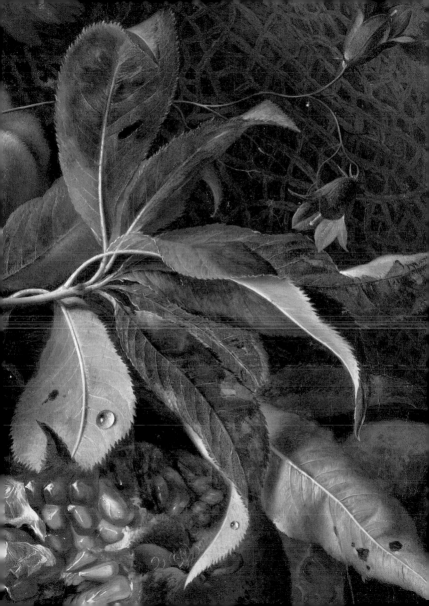

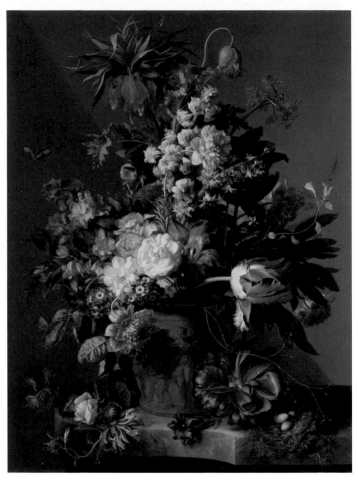

JAN VAN HUYSUM (Dutch, 1682–1749), *Vase of Flowers*, 1722. Oil on panel,
80.3 × 61 cm (31 5/8 × 24 in.). Los Angeles, J. Paul Getty Museum, 82.PB.70.

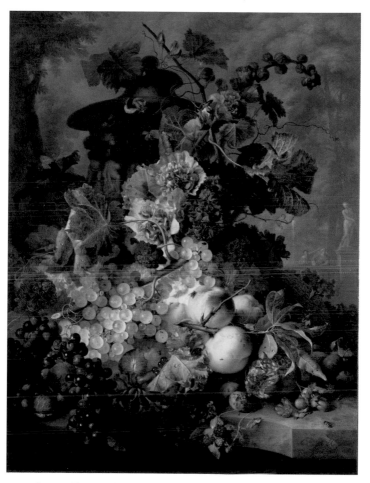

JAN VAN HUYSUM, *Fruit Piece*, 1722. Oil on panel, 80 × 61 cm (31 1/2 × 24 in.).
Los Angeles, J. Paul Getty Museum, 82.PB.71.

Note to the Reader

Painted in 1722 as independent compositions, *Vase of Flowers* and *Fruit Piece* were united by distinguished early collectors and have traversed the centuries together. Acquired a few decades after Van Huysum's death by the wealthy indigo merchant Pieter van Winter, the pair adorned his magnificent house, Saxenburg, on the Keizersgracht in Amsterdam. Following his death in 1807, both paintings passed to his youngest daughter, Anna. She and her older sister, Lucretia, initially kept their father's remarkable collection, which included works by Rembrandt and Vermeer, at Saxenburg, where it was accessible to visitors. Following Anna's marriage to the art collector Joncker Willem van Loon in 1815, Van Huysum's still lifes became part of the couple's prestigious joint collection of artistic marvels. In 1877, to the consternation of observers in the Netherlands, the collection was sold *en bloc* to the Rothschild family in England and Paris. *Vase of Flowers* and *Fruit Piece* entered the collection of Baron Lionel Nathan de Rothschild and were inherited by succeeding generations of the Rothschild family in England, until they were purchased by the J. Paul Getty Museum in 1982, among the first acquisitions following the settlement of J. Paul Getty's estate.

THE WORK OF JAN VAN HUYSUM (1682–1749) epitomizes the rich flower painting tradition of the Netherlands. Supremely talented, industrious, and temperamental, he transformed the rendering of flowers and fruit into a pictorial mode of refined exuberance perfectly in keeping with eighteenth-century tastes. Despite the painstaking nature of his art, Jan became successful and wealthy. He rebuffed persistent attempts to discover the secrets of his remarkable technique, cultivating an air of secrecy that only heightened the public's fascination with his exquisite likenesses of rare and prized blossoms. During his lifetime, his paintings sold for large sums, sometimes exceeding the prices for coveted works by Rubens and Rembrandt. Critics, lamenting what they considered the weaker artistic talents of their own time when compared with the glories of the seventeenth century's Golden Age, considered Van Huysum a heroic figure. After his death, he was profusely praised for having surpassed his predecessors in a widely popular form of art. He was, a fellow artist proclaimed, the "phoenix of flower and fruit painters."

By the time Jan first picked up his brushes, flower painting had long enjoyed great prestige in the artistic culture of the Netherlands. From its origins in the precise renderings of individual blossoms in fifteenth-century illuminated manuscripts to early-seventeenth-century botanical illustrations and densely packed bouquets, Northern painters were renowned for their representations of these delicate and transient marvels of nature. The seventeenth century also witnessed a widespread passion for collecting flowers. Among the most admired species were dramatically shaped and brightly colored varieties, such as the fritillaria and narcissus. Collectors avidly acquired bulbs from southern and central Europe, Asia Minor, and the Americas for cultivation in gardens. The commerce

reached fever pitch with the speculative bubble known as "tulipomania" in the 1630s. The pursuit of rare and prized flowers continued into the eighteenth century, with a popular craze for double hyacinths, while later in the century honeysuckle and fruit flowers such as apple blossoms became the rage. Some flowers, including roses and poppies, remained in fashion. Eighteenth-century connoisseurs relished richly hued flowers and double blossoms, particularly hyacinths, hollyhocks, poppy anemones, the Maltese cross, and auriculas. Both exotic and common species, as well as flowers from different seasons, mingle comfortably in the Getty still lifes.

Jan was steeped from birth in the rich heritage of Dutch still life painting. A member of a large Amsterdam family of painters, he trained in the studio of his father, Justus, where he assisted with decorative paintings and mastered a variety of subjects, including idyllic landscapes and still lifes. A flower piece dated 1701, when Jan was nineteen, marked the beginning of his independent career. He married in 1704, and after a few lean years he and his wife moved to the well-situated house she inherited on the Leidsegracht, named Het Vergulde Hek (The Gilded Gate). His professional fortunes were transformed in 1716, when one of his flower paintings was shown to the connoisseur (and his future biographer) Johan van Gool and to the prince of Hesse-Kassel, who later purchased several works. Jan's fame spread rapidly, and he soon became one of the most successful painters in Europe, specializing in fruit and flower pieces and Arcadian landscapes. Competition for his works at auction was fierce, and the high prices his paintings commanded served to concentrate his patrons within elite circles. In the Netherlands, nearly every leading collection contained one of what were known as the "artistic miracles of Van Huysum."

The joyous exuberance of Jan's floral subjects, however, contrasted with his personal and familial tragedies. Only three of the twelve Van Huysum children outlived their parents. Jan's surviving son, Jan Jr., a profligate spender and troublemaker, left Amsterdam permanently after an altercation with his father and died in the Dutch East Indies in 1752. Accounts

of the elder Van Huysum's unstable temper in his later years suggest that he may have suffered from "painters' disease," brought about by prolonged contact with lead-based pigments. Jan's biographer alleged that he closely guarded his studio practice from other painters, including his brothers. He trained only one pupil, Margareta Haverman, and she eventually left Amsterdam after Jan accused her of "misconduct." Such travails notwithstanding, Jan painted several hundred works over the course of his career, and at his death in 1749 his mastery of still life painting was unrivaled.

Jan's career flourished in large part due to his savvy management of his reputation. He emphasized his practice of painting directly from nature, an approach used by the most lauded painters of the early seventeenth century but unusual in his own time. Although he may have used different sources for his still life subjects, including pattern books and chalk compositional drawings (though none are known for the Getty paintings), there is no reason to doubt his reliance on direct observation. In one letter to a patron, for instance, Jan stated that he had not completed a painting because he had been unable to obtain a particular yellow rose. A number of his paintings bear two dates and were probably executed over the course of two seasons. Jan himself maintained a garden in Amsterdam, and he visited the nearby city of Haarlem, a center for flower cultivation. In Haarlem, friends would share with him rare and important blossoms. Many details in the Getty still lifes, such as the fine spines on the stem of the red poppy (pl. 10), strongly suggest close observation of actual flowers.

Trembling water droplets, crawling insects, fresh and fading petals, mouthwatering fruit—the illusions of reality in *Vase of Flowers* and *Fruit Piece* invite close scrutiny of these remarkable works. Jan executed them with great attention, and they are among his most innovative paintings, inaugurating new compositional and lighting strategies that would shape his future work. From about 1710 to 1720, in a manner reminiscent of the mid-seventeenth-century painter Jan Davidsz. de Heem, Jan had placed his dense bouquets against solid, dark backgrounds in order to accentuate

their brilliant colors and diverse forms. In the early 1720s, at the suggestion of a friend, he introduced new backdrops—in *Flowers* pale yellow-green and in *Fruit* Arcadian scenery that was a variation of his own landscape subjects. To portray flowers and fruit against these paler settings, he devised a complex system of illumination, including backlighting that revealed not only blossoms at the rear of the bouquet but also the bouquet's innermost elements. Strong frontal illumination cast forms into clear relief, creating a powerful sense of reality.

Jan's extraordinary bouquets possess a dynamic life force generated by the play between large blossoms (pl. 2) and fruit (pl. 9), as well as by the whimsical tendrils and stalks that meander outward from the bouquet centers. In *Vase of Flowers*, which evokes a Baroque sensibility, the diagonal axis of the bouquet—from the curved honeysuckle in the lower left up to the reverse curve of the poppy at the top—is strikingly crossed by a horizontal axis, articulated in a palette of whites. The spray of honeysuckle, morning glory, and rose (pl. 11) that seems to have fallen from the vase is a particularly charming element. The vase itself offers a foundation for the surging forms, and it complements the botanical textures with reliefs drawn from the artist's imagination. An exquisitely detailed chaffinch nest (pl. 14), turned invitingly for our inspection, anchors the composition. In *Fruit Piece*, by contrast, we see an asymmetrical composition, in which the rococo S-form leads the eye from the hollyhock stalk at the top of the painting through the globes of fruit at the base. Cascading over the marble ledge, unbound by the constraints of a vase, the fruit and flowers encroach on the viewer's space. In addition, the flying, crawling insects in both paintings contribute to the liveliness of the bouquets. Jan included common native species of butterflies and flies. Long used by artists to "fool the eye," the insects are clearly identifiable. The ants that invade both works provide a

subnarrative of industry; looking at its fellows, one ant even mimics our observation (pl. 12).

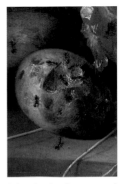

Jan's vivid and carefully orchestrated palette of brilliant oranges, reds, and purples appealed to the contemporary public's delight in bright colors. Subtle transitions within color families add richness, such as the purples and blues of the grapes and iris in *Fruit* (pl. 3) and the white and pale pink combinations in *Flowers* (pl. 13). Chromatic juxtapositions, including the hollyhock, larkspur, and Maltese cross grouping in *Fruit* (pl. 2), as well as the blue gentian and red peony pairing in the foreground of *Vase of Flowers,* intrigue the eye. Some of these effects have changed over time, as a few of Jan's pigments were unstable and have discolored in the years since these works were executed. The brown hues in the reddish tulip at the center of *Vase of Flowers* (pl. 17), for example, were once a vibrant yellow, and the bluish tint of certain leaves has resulted from the fading of a translucent yellow glaze.

While Jan's secrecy concerning his studio practice encouraged speculation about his methods, we now know that his remarkable depictions of natural subjects resulted from a mastery of traditional oil painting techniques and materials. One of the last great practitioners of fine manner painting (*fijnschilderij*), he preferred to paint on hard, smooth surfaces. Jan often used panels of oak and copper for his compositions; occasionally he used canvas. *Vase of Flowers* and *Fruit Piece* were painted on single planks of mahogany. He prepared his surface with a fine chalk and glue ground colored by different pigments, creating a brownish effect in the background of Flowers and a lighter and brighter overall appearance in *Fruit*. Pale brown underpainting indicated areas of light and shade. (The unfinished painting that Jan holds in his portrait on the back flap of this book demonstrates this approach.) By applying only a few, thin layers of glaze, Jan was

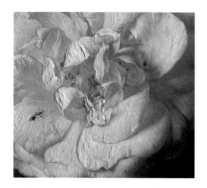

able to control translucent light and create illusions of details and texture. He worked quickly, often without letting the paint dry completely, thereby erasing traces of his brush. In contrast to smooth application, as in the satiny peony petals (pl. 14), Jan also created remarkable textural effects. Some are subtle, such as the bloom on the Muscat grapes (pl. 16) and the powdery surface of the auricula petals (pl. 17), while others are more conspicuous, such as the crumpled center of a rose (pl. 17), or the veining at the base of a tulip (pl. 5).

Flower and fruit pieces held myriad associations for eighteenth-century viewers fortunate enough to study them closely, as they were intended to be seen. Although the brevity of life was not their primary theme, the curling petals and bent stems of Jan's lavish bouquets, as well as the exposed fruit seeds and gnawed flesh, convey the passage of time. The Getty still lifes may represent complementary seasons: *Vase of Flowers*, with its bird's nest and spring and early summer blooms, evokes fresh beginnings, while *Fruit Piece*'s orange and purple tonalities, along with its late summer and autumnal fruit and nuts, bring to mind the bounty of fall. Depicting familiar and prized varieties of fruits and flowers in exuberant celebration, Van Huysum's still lifes have allowed viewers over the centuries to rejoice in nature as well as in the artist's painterly skill.

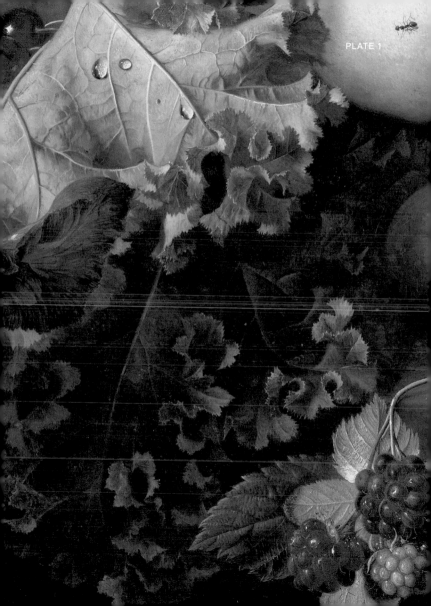

PLATE 1

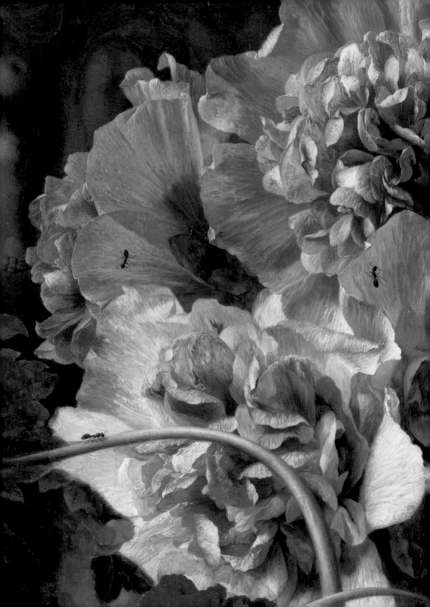

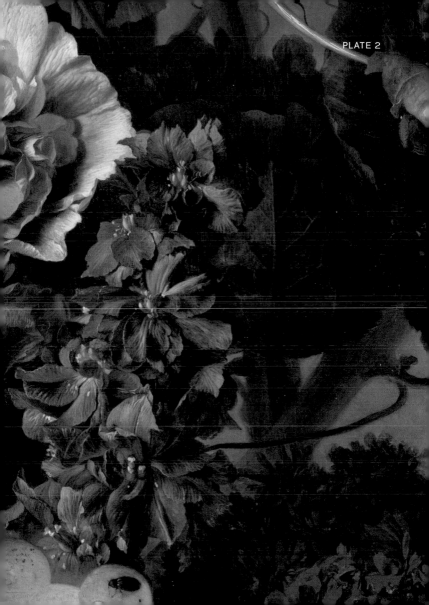

PLATE 2

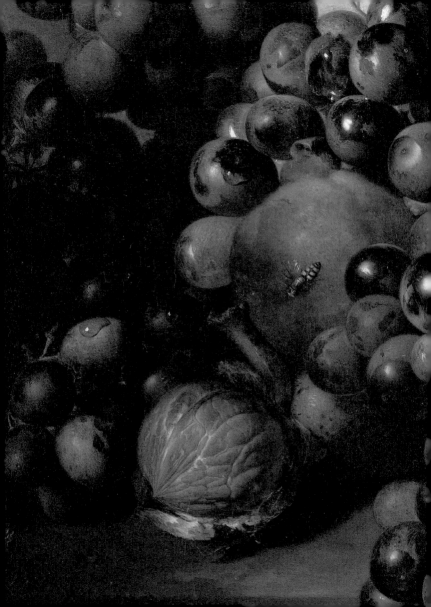

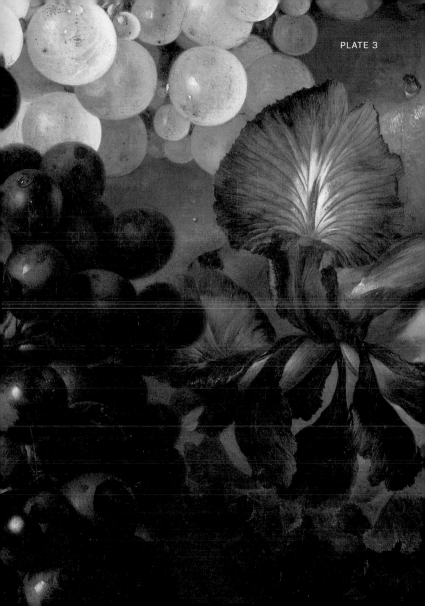
PLATE 3

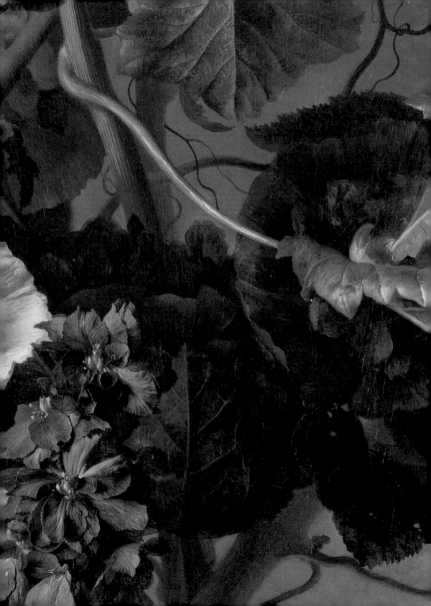

PLATE 4

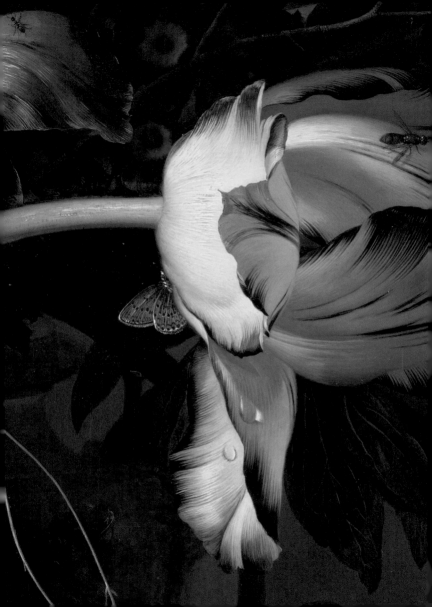

PLATE 5

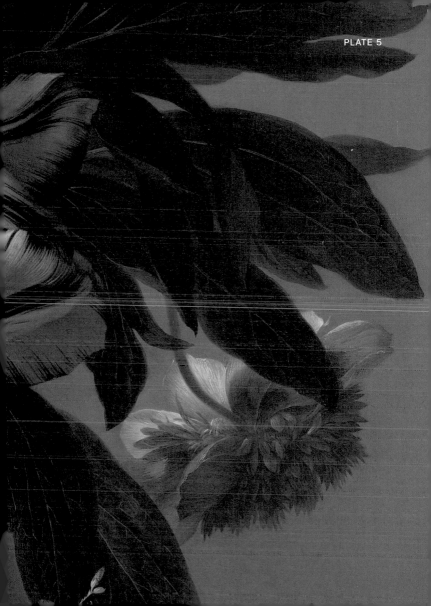

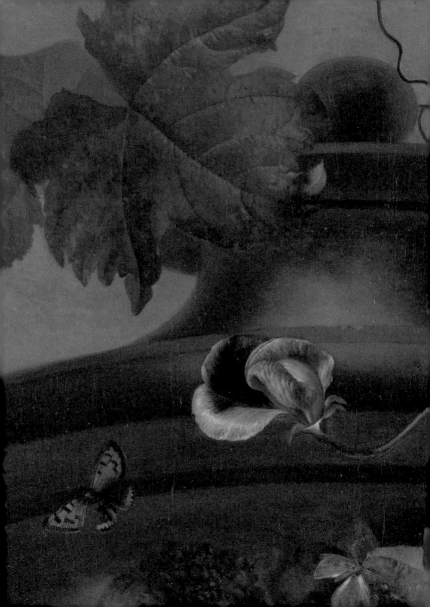

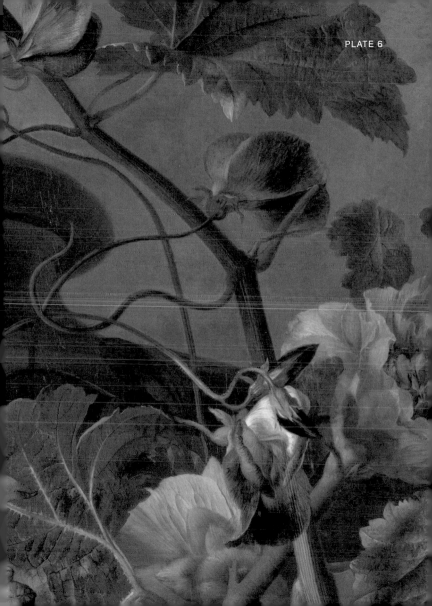
PLATE 6

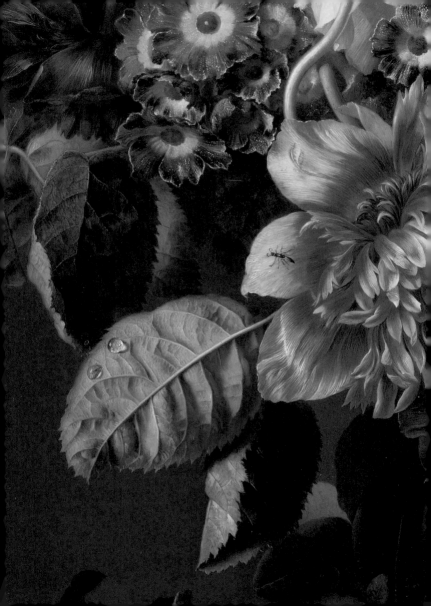

PLATE 7

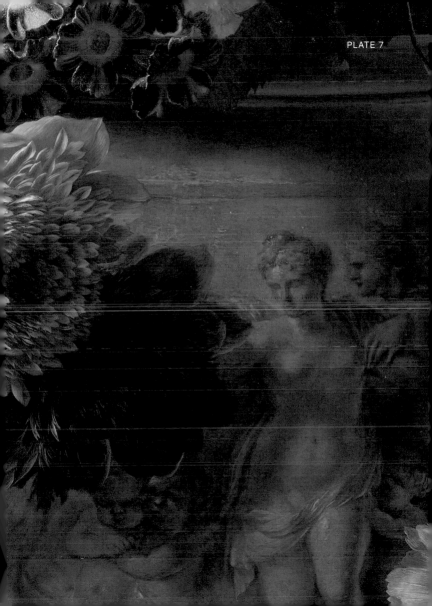

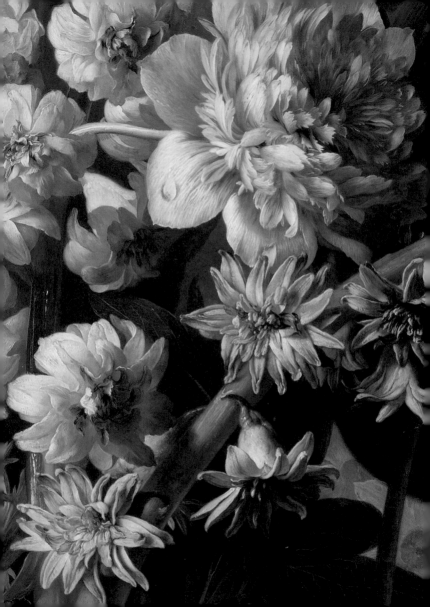

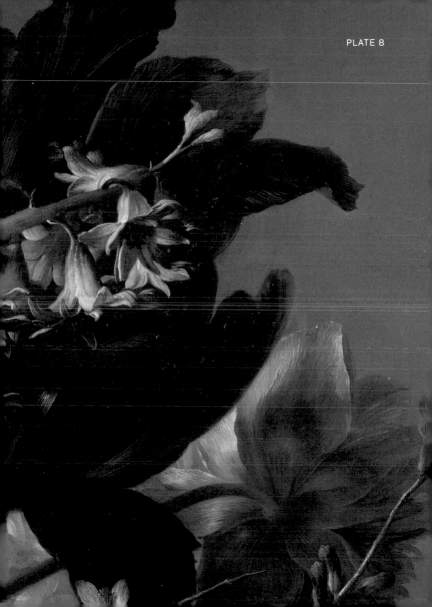

PLATE 8

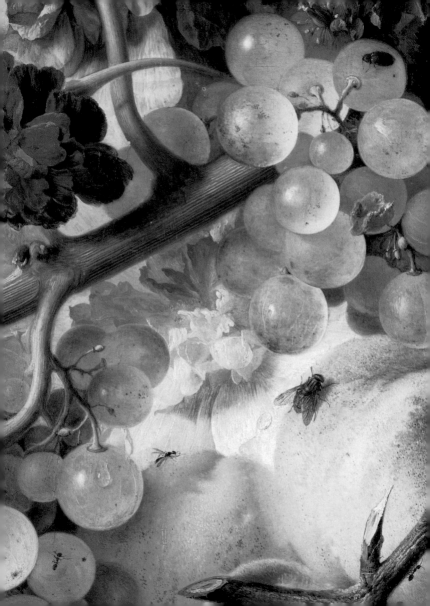

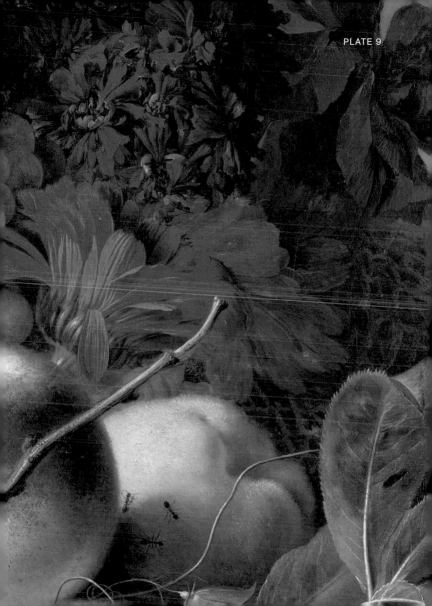

PLATE 9

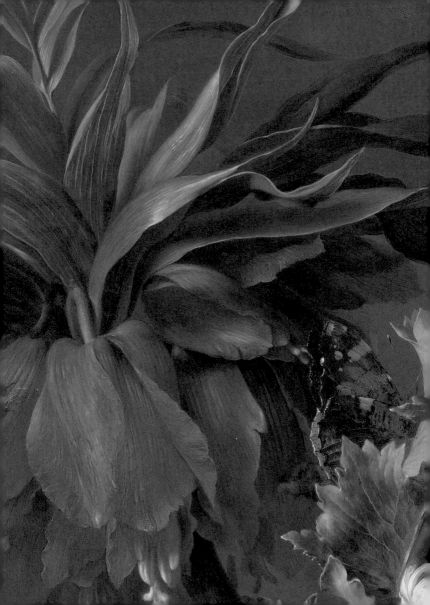

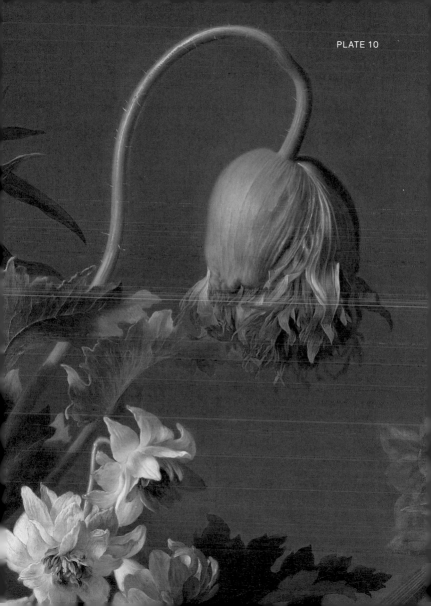

PLATE 10

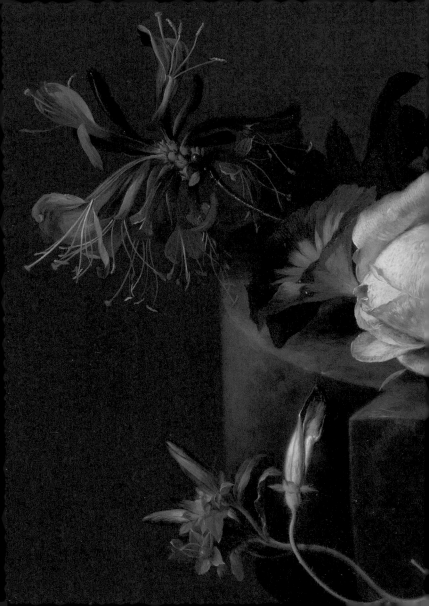

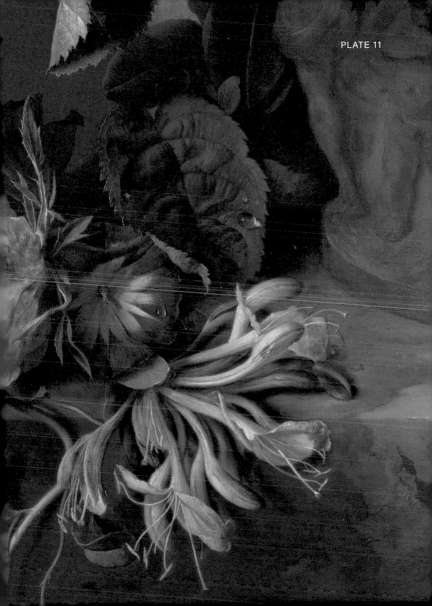
PLATE 11

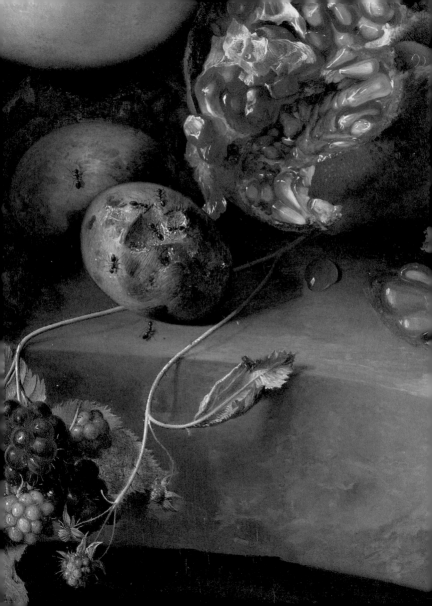

PLATE 12

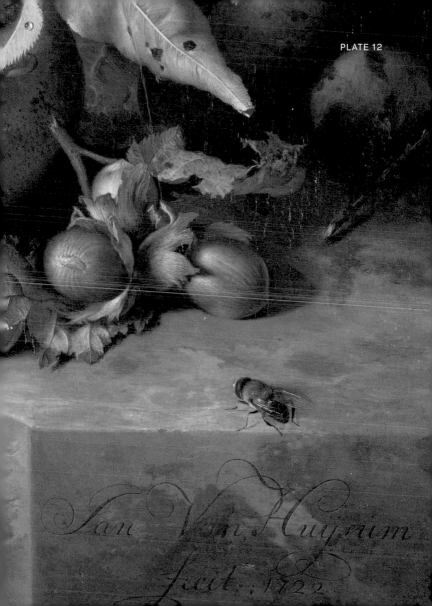

Ian Van Huysum
fecit : 1722

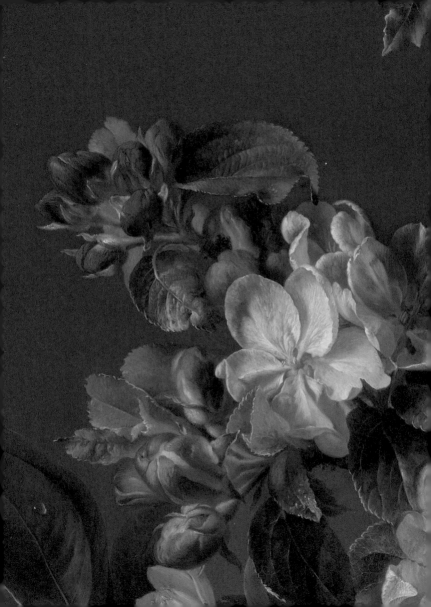

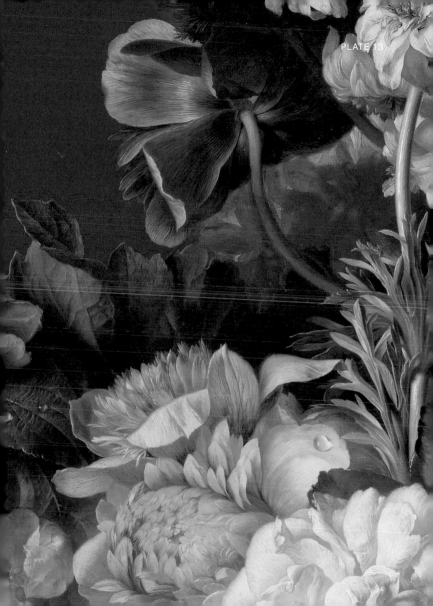
PLATE 13

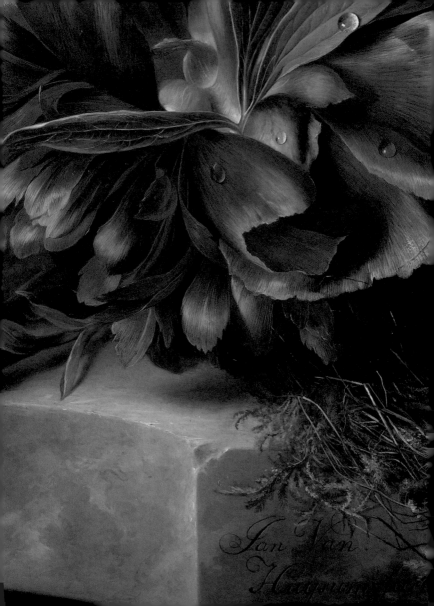

Jan Van
Huysum

PLATE 14

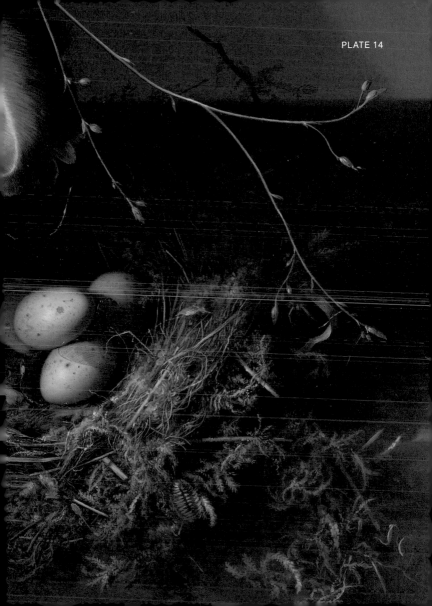

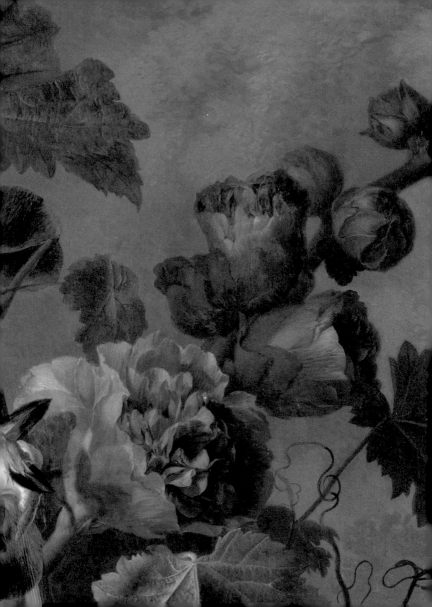

PLATE 15

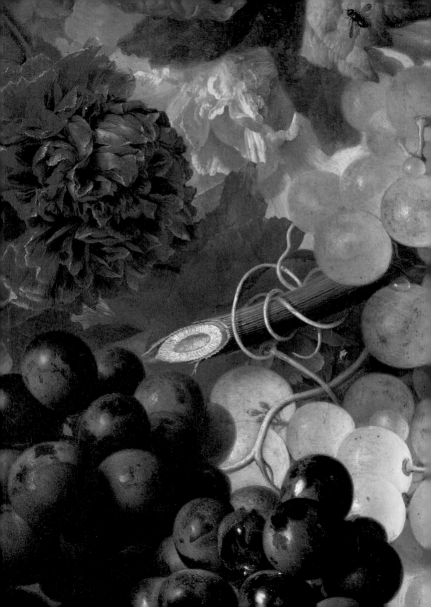

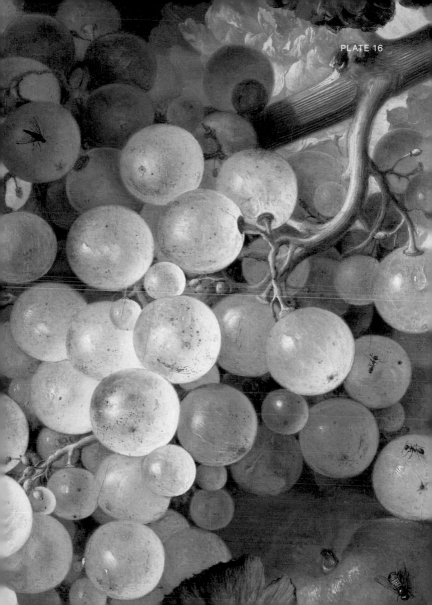
PLATE 16

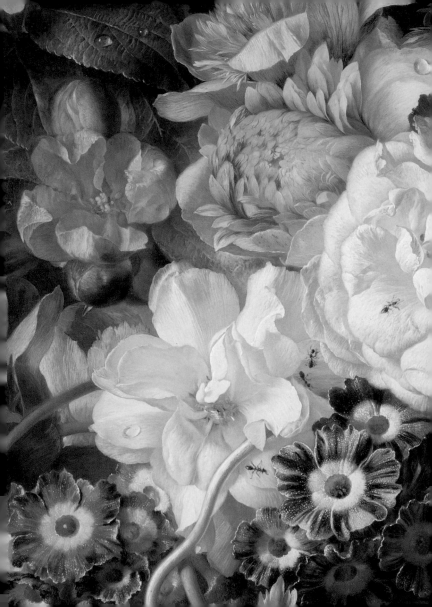

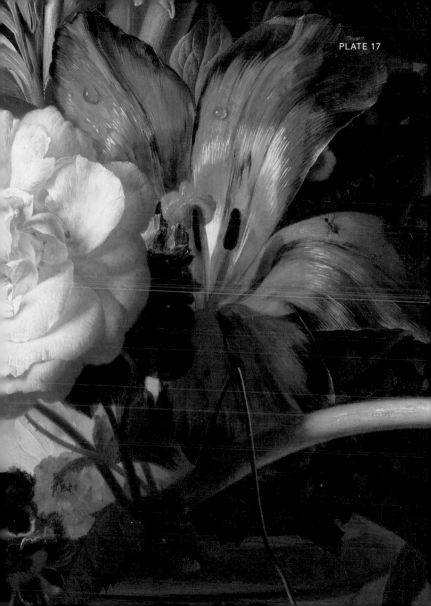
PLATE 17

Plates

Note: All identifications are clockwise from upper left.

Frontispiece *Fruit Piece*
Housefly (*Musca domestica*), peaches
(*Prunus persica*), yellow meadow ants
(*Lasius flavus*), muskmelon (*Cucumis melo
reticulatus*), harebells (*Campanula rotun-
difolia*), purplish plum (*Prunus domestica*),
pomegranate (*Punica granatum*), crisp
mallow foliage (*Malva crispa*).

Plate 1 *Fruit Piece*
Red currents (*Ribes rubrum*), crisp mallow
foliage (*Malva crispa*), peach (*Prunus
persica*), yellow meadow ant (*Lasius flavus*),
blue plum (*Prunus domestica*) [just seen at
edge], raspberries (*Rubus idaeus*), English
iris (*Iris latifolia*).

Plate 2 *Fruit Piece*
Pink hollyhock (*Alcea rosea pseudoplena*),
yellow meadow ants (*Lasius flavus*), larkspur
(*Delphinium elatum semiplenum*), muscat
grape foliage (*Vitis vinifera*), hollyhock [in
shadow], Maltese cross (*Lychnis chalce-
donica plena*), muscat grapes (*V. vinifera*),
leaf beetle (*Chrisomela cf. varians*).

Plate 3 *Fruit Piece*
Black grapes (*V. vinifera*), muscat grapes
(*V. vinifera*), nectarines (*Prunus persica* var.
nectarine), English iris (*I. latifolia*), crisp
mallow foliage (*Malva crispa*), apricot
(*Prunus armeniaca*), hoverfly (*Syrphus
ribesii*), walnut (*Juglans regia*).

Plate 4 *Fruit Piece*
Muscat grape foliage (*V. vinifera*), pink hol-
lyhock (*Alcea rosea pseudoplena*), larkspur
(*D. elatum semiplenum*).

Plate 5 *Vase of Flowers*
Yellow tulip hybrid (*Tulipa chrysantha* × *Tulipa
clusiana*), yellow meadow ant (*Lasius flavus*),
baguette tulip (*Tulipa stellata* × *Tulipa clusi-
ana*), blue butterfly (*Lycaenidae*), ruby-tailed
wasp (*Chrysis ignite*), peony foliage (*Paeonia
officinalis plena*), pale lilac poppy anemone
(*Anemone coronaria pseudoplena albidoli-
lacina*), golden flax stem (*Linum flavum*).

Plate 6 *Fruit Piece*
Muscat grape foliage (*V. vinifera*), sweet pea
(*Lathyrus odoratus*), pink hollyhock (*Alcea
rosea pseudoplena*), small heath butterfly
(*Coenonympha pamphylus*) [bottom, just seen],
small copper butterfly (*Lycaena phlaeas*).

Plate 7 *Vase of Flowers*
Violet poppy anemone (*Anemone coronaria
pseudoplena purpurea*), beige-violet auricula
(*Primula* × *pubescens avellana*), whitish pink
poppy anemone (*Anemone coronaria pseu-
doplena albo-rosea*), digger wasp (*Trypoxylon
figulus?*), whitish violet auricula (*Primula
× pubescens albo-violacea*), dark red poppy
anemone (*Anemone coronaria pseudoplena
atrorubra*), white rose foliage (*Rosa* × *alba*).

Plate 8 *Vase of Flowers*
White hyacinth (*Hyacinthus orientalis plenus
albus*), cream-pink poppy anemone (*Anemone
coronaria pseudoplena cremeo-rubescens*), pur-
ple tulip hybrid (*Tulipa undulatifolia* × *Tulipa
agenensis*), lilac-pink poppy anemone (*Anemone
coronaria pseudoplena lilacino-rosea*), dwarf
almond (*Prunus tenella*), golden narcissus
(*Narcisus tazetta* subsp. *Aureus*), pale blue
hyacinth (*H. orientalis plenus pallidocoeruleus*).

Plate 9 *Fruit Piece*
Pink hollyhock (*Alcea rosea pseudoplena*), lark-spur (*D. elatum semiplenum*), muscat grapes (*V. vinifera*), stem gall fly (*Urophora cardui*), Maltese cross (*Lychnis chalcedonica plena*), African marigold (*Tagetes erecta rubra*), pot marigold (*Calendula officinalis aurantiaca*), muskmelon (*Cucumis melo reticulates*), harebell (*Campanula rotundifolia*), peaches (*Prunus persica*), yellow meadow ants (*Lasius flavus*), housefly (*Musca domestica*), light pink hollyhock (*Alcea rosea subplena pallidorosea*).

Plate 10 *Vase of Flowers*
Crown imperial (*Fritellaria imperialis*), red opium poppy (*Papaver somniferum pseudople-num cinnabarinum*), painted lady butterfly (*Cynthia cardui*), white hyacinth (*H. orientalis plenus albus*).

Plate 11 *Vase of Flowers*
Honeysuckle (*Lonicera periclymenum*), dwarf morning glory (*Convolvulus tricolor*), French rose (*Rosa gallica plena*), white rose foliage (*Rosa × alba*).

Plate 12 *Fruit Piece*
Peach (*Prunus persica*), pomegranate (*Punica granatum*), violet plums (*Prunus domestica*), hazelnuts (*Corylus avellana*), honeybee (*Apis mellifera*), raspberries (*Rubus idaeus*), blue plums (*Prunus domestica*), yellow meadow ants (*Lasius flavus*).

Plate 13 *Vase of Flowers*
Apple blossom (*Malus × domestica*), pale indigo poppy anemone (*Anemone coronaria pseudoplena pallidoindogotica*), white hyacinth (*H. orientalis plenus albus*), white rose (*Rosa × alba*), pale pink poppy anemone (*Anemone coronaria pseudoplena pallidorosea*), pale lilac poppy anemone (*Anemone coronaria pseu-doplena albidolilacina*), orange blossom foliage (*Citrus aurantium*).

Plate 14 *Vase of Flowers*
Peony (*Paeonia officinalis plena*), golden flax (*Linum flavum*), chaffinch nest with eggs (*Fringilla coelebs*), dead mayfly (*Ephemerop-tera*) and dead pill bug (*Philoscia muscorum*).

Plate 15 *Fruit Piece*
Muscat grape foliage (*V. vinifera*), pink hol-lyhock (*Alcea rosea pseudoplena*), sweet pea (*Lathyrus odoratus*).

Plate 16 *Fruit Piece*
Double field poppy (*Papaver rhoeas plenum*), pale lilac hollyhock (*Alcea rosea plena pallidolilaciana*), ruby-tailed wasp (*Chrysis ignita*), muscat grapes (*V. vinifera*), stem gall fly (*U. cardui*), yellow meadow ants (*Lasius flavus*), pale pink hollyhock (*Alcea rosea subplena pallidorosea*), nectarines (*Prunus persica* var. *nectarine*), blue hoverfly (*Ophyra leucostoma*), English iris (*I. latifolia*) [just seen], black grapes (*V. vinifera*).

Plate 17 *Vase of Flowers*
Pale lilac poppy anemone (*Anemone coronaria pseudoplena albidolilacina*), pale pink poppy anemone (*Anemone coronaria pseudoplena pallidorosea*), white rose (*Rosa × alba*), yellow meadow ants (*Lasius flavus*), yellow tulip hybrid (*Tulipa chrysantha × Tulipa clusiana*), stem of baguette tulip (*Tulip stellata × Tulipa clusiana*), golden flax (*Linum flavum*), dwarf morning glory (*Convolvulus tricolor*), golden narcissus (*N. tazetta* subsp. *Aureus*), whitish violet auricula (*Primula × pubescens albo-violacea*), beige-violet auricula (*Primula × pubescens avellana*), pink poppy anemone (*Anemone coronaria pseudoplena rosea*), apple blos-som (*Malus × domestica*).

The author gratefully acknowledges the botanical expertise of Sam Segal and the research of Joris Dik and Mariëlle Ellens.

Published by the J. Paul Getty Museum

Getty Publications
1200 Getty Center Drive Suite 500
Los Angeles CA 90049-1682
www.gettypublications.org

Tevvy Ball, *Project Editor*
Whitney Braun, *Copy Editor*
Kurt Hauser, *Designer*
Suzanne Watson, *Production Coordinator*

Printed in Italy

Library of Congress Cataloging-in-Publication Data

Woollett, Anne T.
 Miraculous bouquets : flower and fruit paintings by Jan van Huysum / Anne T. Woollett.
 p. cm.
 ISBN 978-1-60606-090-2 (pbk.)
1. Huysum, Jan van, 1682-1749--Themes, motives. 2. Flowers in art. 3. Fruit in art. I. Huysum, Jan van, 1682-1749. II. Title. III. Title: Flower and fruit paintings by Jan van Huysum.
 ND653.H87W65 2011
 759.9492--dc23

 2011016544

Cover *Fruit Piece*
Larkspur (*Delphinium elatum semiplenum*), Maltese cross (*Lychnis chalcedonica plena*), African marigold (*Tagetes erecta rubra*), crisp mallow foliage (*Malva crispa*), muskmelon (*Cucumis melo reticulates*), harebells (*Campanula rotundifolia*), pot marigold (*Calendula officinalis aurantiaca*), peaches (*Prunus persica*), yellow meadow ants (*Lasius flavus*), housefly (*Musca domestica*), muscat grapes (*Vitis vinifera*), leaf beetle (*Chrisomela*).